Taxidermy Gone Wrong

Many animals died in the making of this book...

Taxidermy Gone Wrong

The Funniest, Freakiest (and Outright Creepiest) Beastly Vignettes

Rob Colson

HARPER
DESIGN

An Imprint of HarperCollinsPublishers

First published in Great Britain in 2020 by
Cassell, an imprint of Octopus Publishing Group Ltd.

HarperCollins books may be purchased for educational, business, or sales
promotional use. For information please email the Special Markets Department at
SPsales@harpercollins.com.

Published in 2020 by
Harper Design
An Imprint of HarperCollins*Publishers*
195 Broadway
New York, NY 10007
Tel: (212) 207-7000
Fax: (855) 746-6023
harperdesign@harpercollins.com
www.hc.com

Distributed in North America by
HarperCollins Publishers
195 Broadway
New York, NY 10007

ISBN 978-0-06-306054-8

Printed and bound in China

First Printing, 2020

Written, researched, edited and designed by Tall Tree Limited

Publishing Director: Trevor Davies
Author and picture research: Rob Colson
Design: Jonathan Vipond
Assistant Editor: Sarah Kyle
Senior Production Manager: Peter Hunt

contents

Introduction

At first glance, the world of taxidermy may seem a bit, well, stuffy. Dedicated experts, with detailed knowledge of biology and anatomy, labor away behind the scenes in museums to re-create life-like animals and give us an idea of how they lived. Well, forget about all that business. There is a new breed of taxidermists in town who have said "Stuff that! We're going to show you animals as they have never looked or lived before." These taxidermists give their animals clothes. They put them on bicycles. They turn them into acrobats and sports stars. They transform them into figures from mythology. And they mix and match to make brand-new creatures. Pigs will finally fly!

Taxidermy first went wild in Victorian times. In the 1850s, strange dioramas began to appear in a pub in the sleepy English village of Bramber. The pub owner's son, Walter Potter, had dabbled in taxidermy as a boy in an attempt to preserve his much-loved pet canary. As he practiced his art, Potter let his imagination run amok, creating scenes filled with animals in distinctly human poses and predicaments, from kittens at a wedding to rabbits in a classroom. Following his lead, Victorian taxidermists started to produce all manner of anthropomorphic scenes. Potter himself opened a museum to display his weird and wonderful dioramas.

animals
with attitude

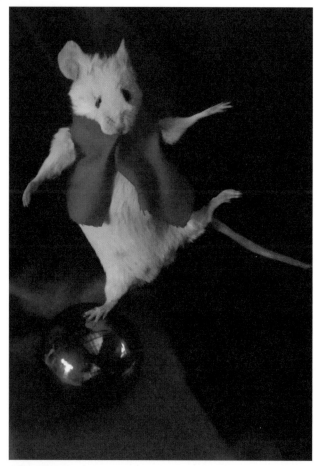

Balancing act

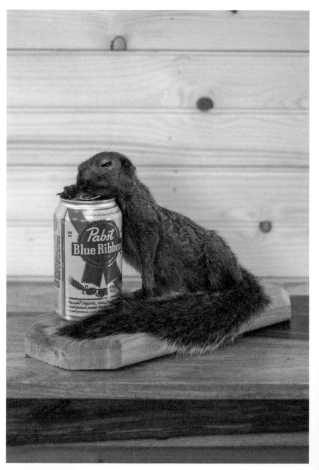

Sozzled squirrel

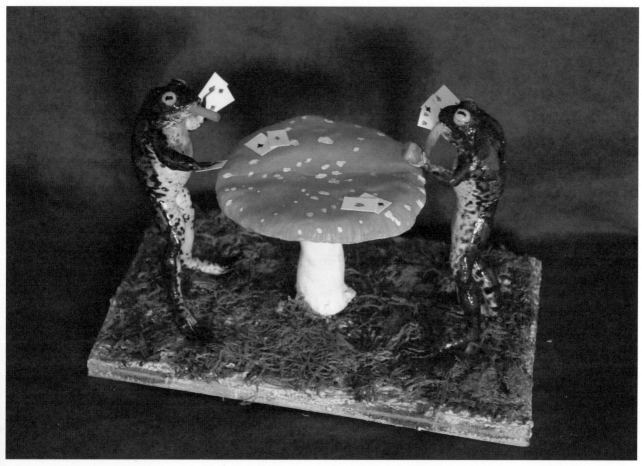

Poker faces at the Toadstool Casino

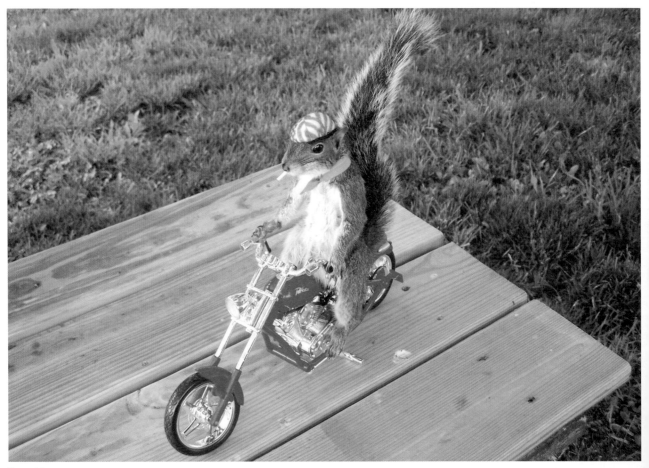

Easy rider

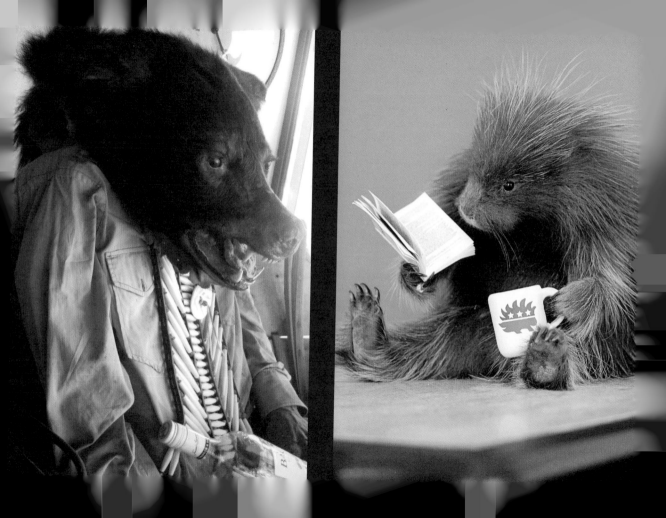

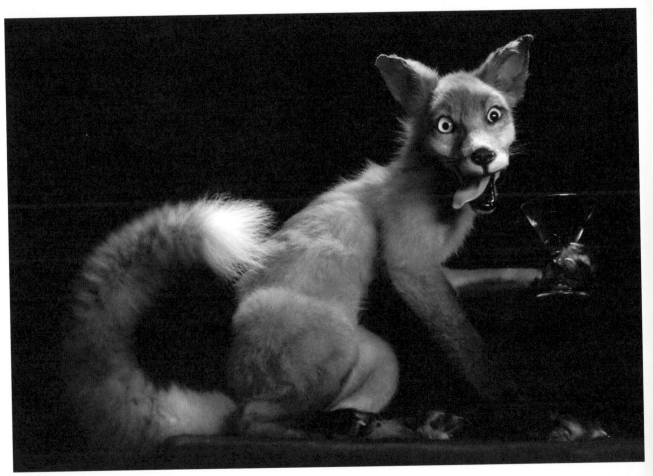

A frisky fox both shaken and stirred

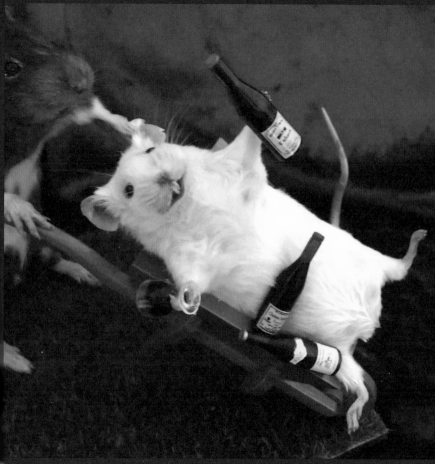

"Show me the way to go home..."

Extreme urban foraging

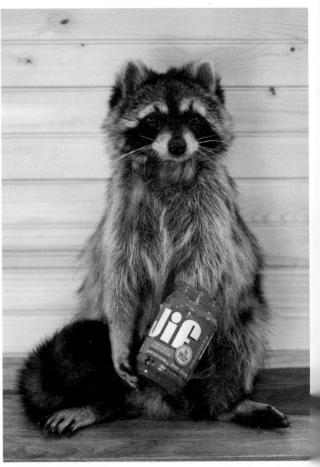

What are you looking at?

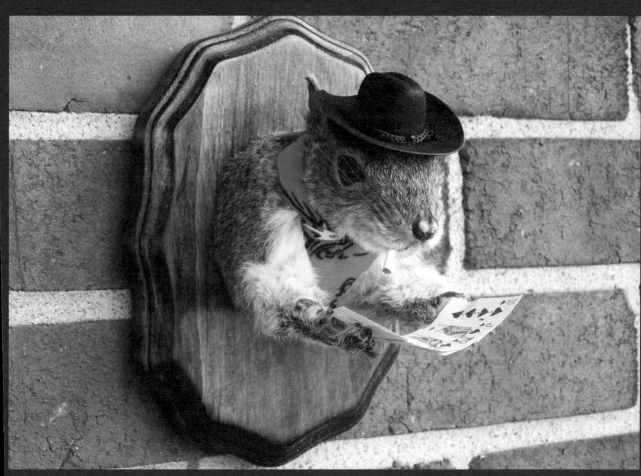

A flushed cowsquirrel

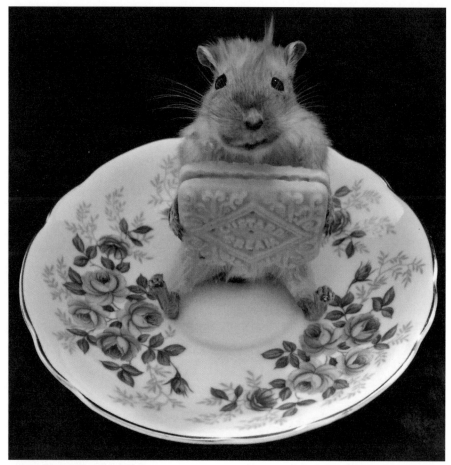

Crumbs. Caught in the act again.

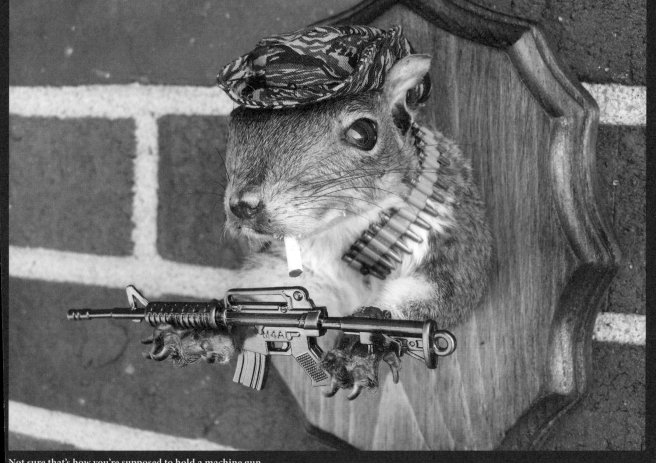

Not sure that's how you're supposed to hold a machine gun

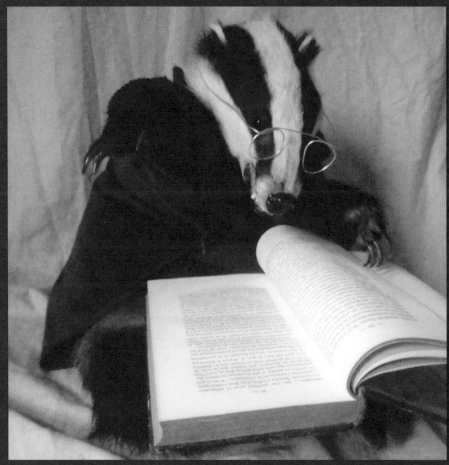

Professor Brock

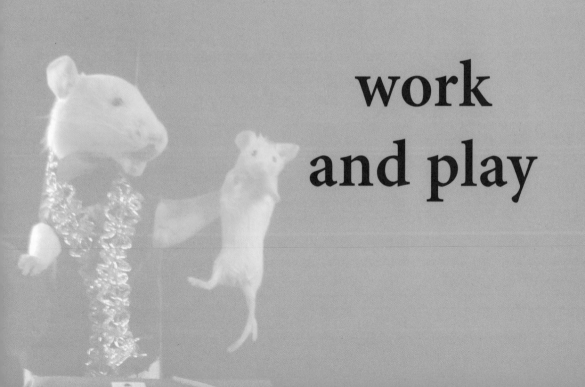

work
and play

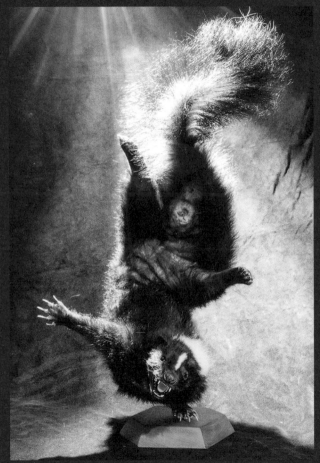

Breakdancing skunk
From the crazy mind of Toronto's finest, Jeremy Johnson

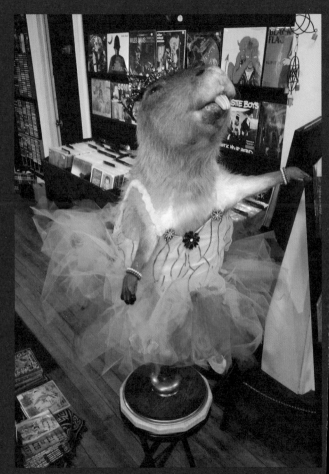

Balancing ballerina – this pirouetting capybara spins on the spot!

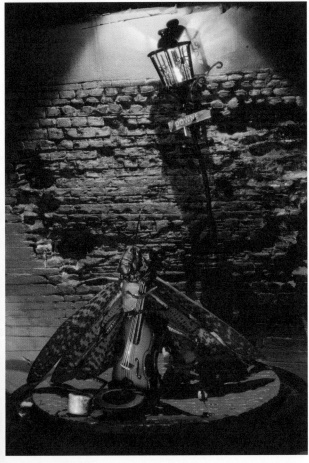

Busking grasshopper

Disco opossum

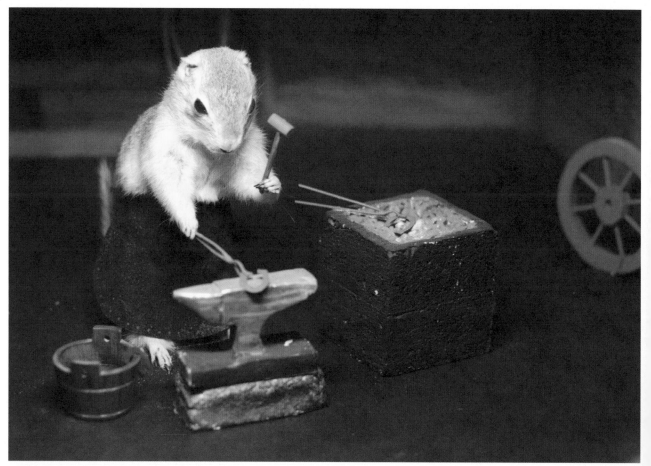

A gopher blacksmith makes shoes for a tiny, tiny horse.

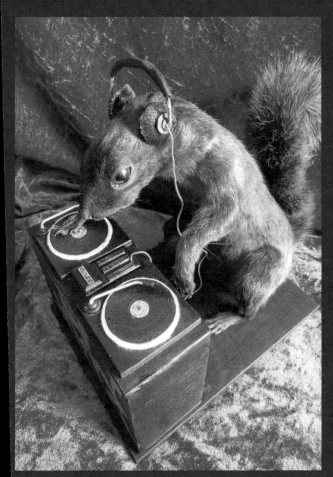

Red Hot DJ, making some new scratches

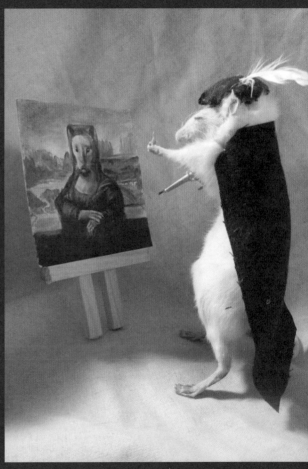

Mona Mouse

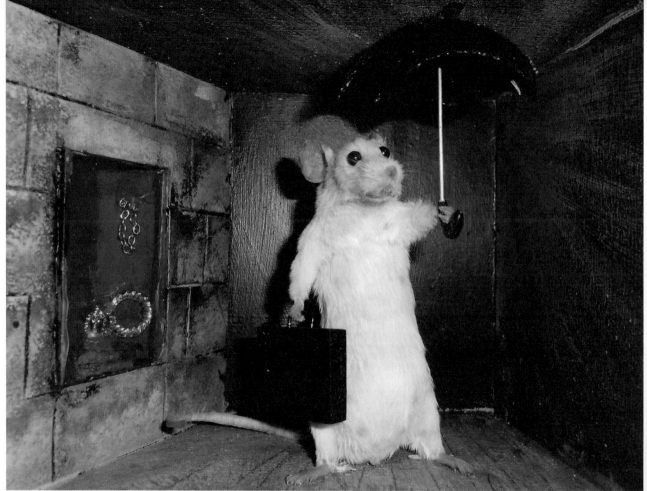

No-Clothes Friday at the office

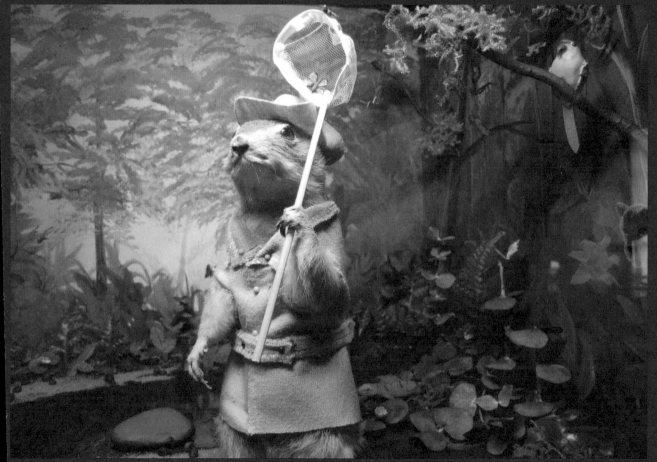

An intrepid gopher trades the prairie for the jungle.

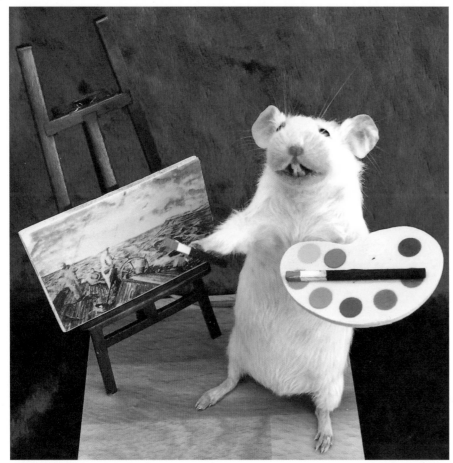

Portrait of the artist as a young mouse

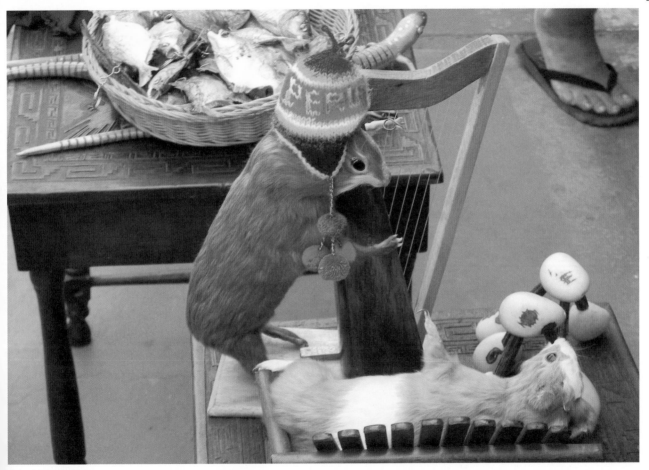

Harping guinea pig
Spotted in a Peruvian market. Next to the dried fish, naturally.

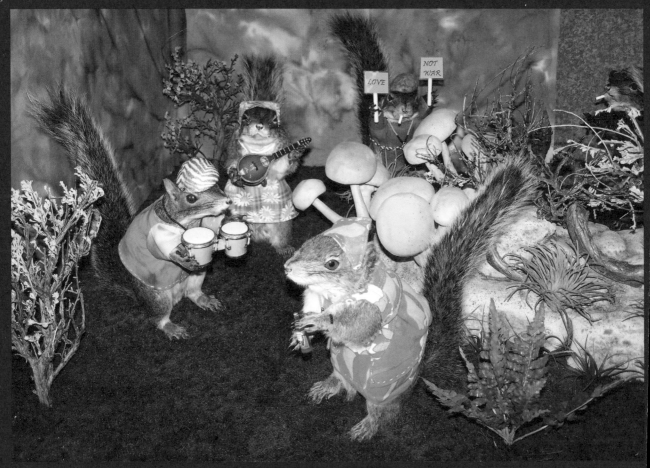

Bongos? Check. Mandolin? Check. Ironic headgear? Check. It's the lesser-spotted hipster gray.

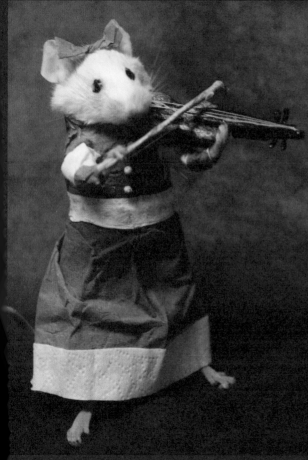

furry fiddler

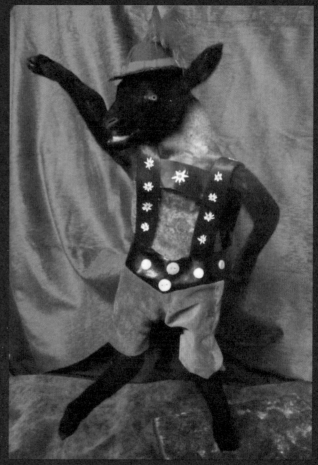

Bavarian boogie

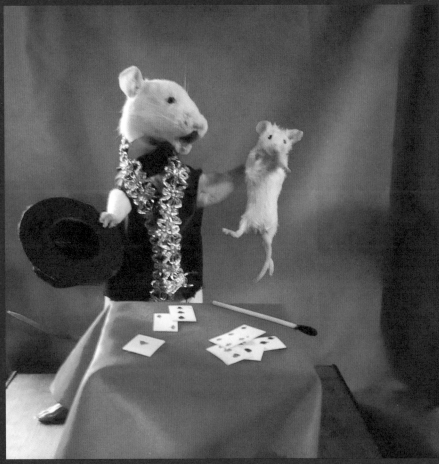

"Tah Dah!"

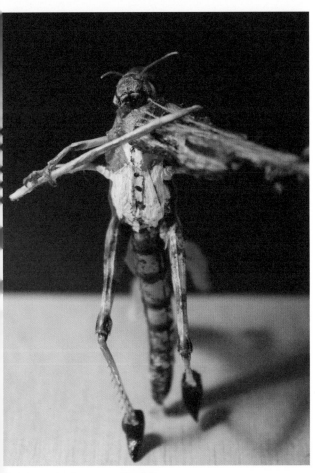

A virtuoso grasshopper on the violin

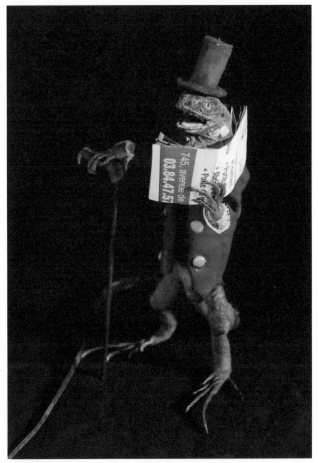

Lounge lizard

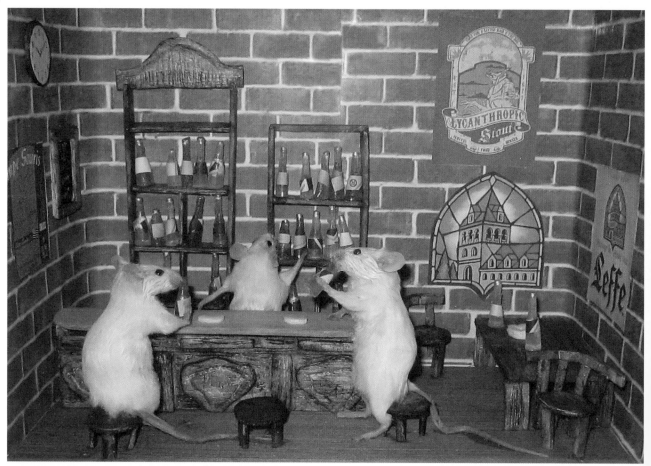

Cheers! Merry mice sharing tall tales, short tails and a pint

sporting
triumphs

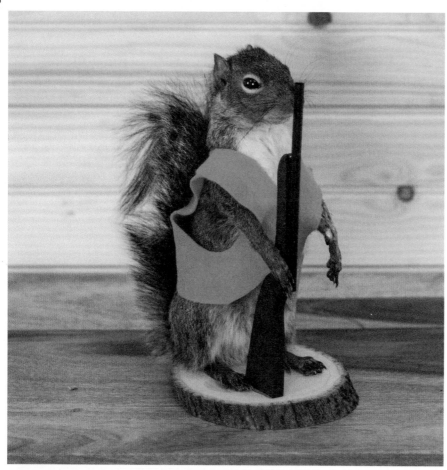

Hunting in a high-vis? Good luck with that!

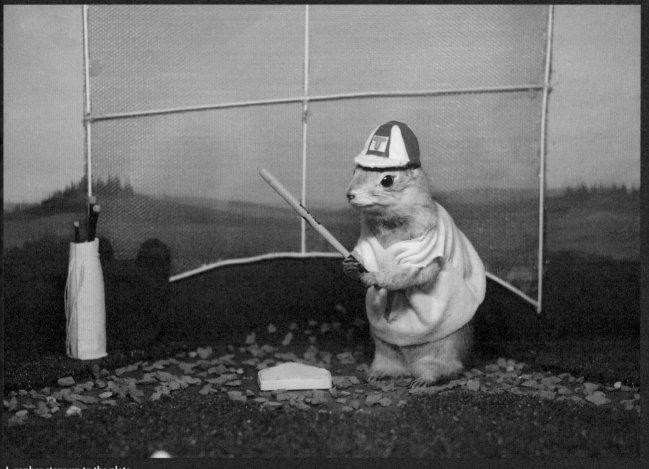

A gopher steps up to the plate.

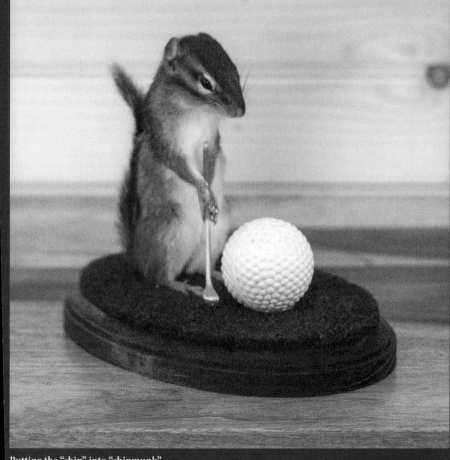

Putting the "chip" into "chipmunk"

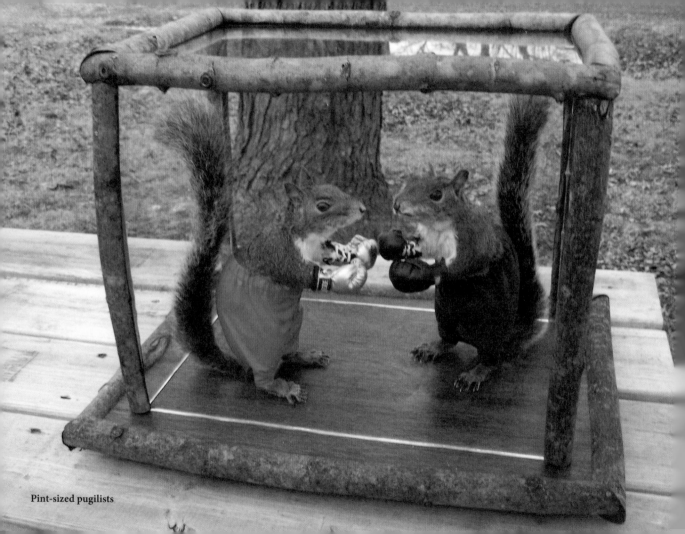

Pint-sized pugilists

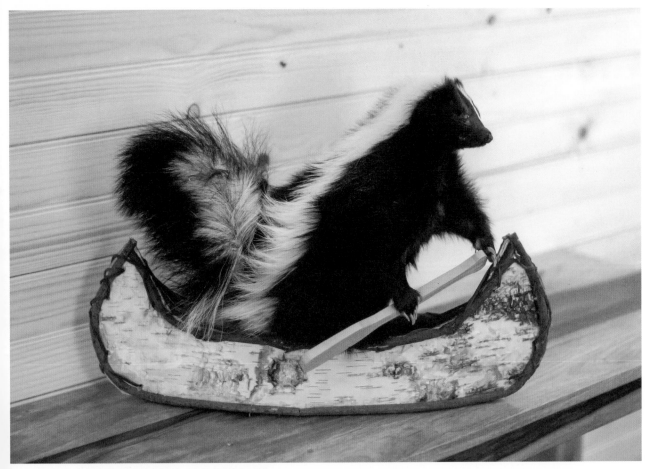

Head forward, body braced, this skunk is ready for the rapids.

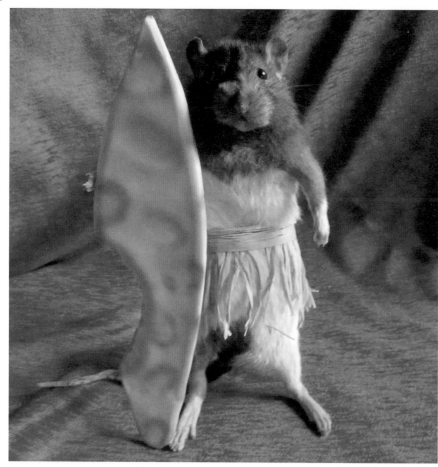

A lucky escape for this wave-riding beach rat

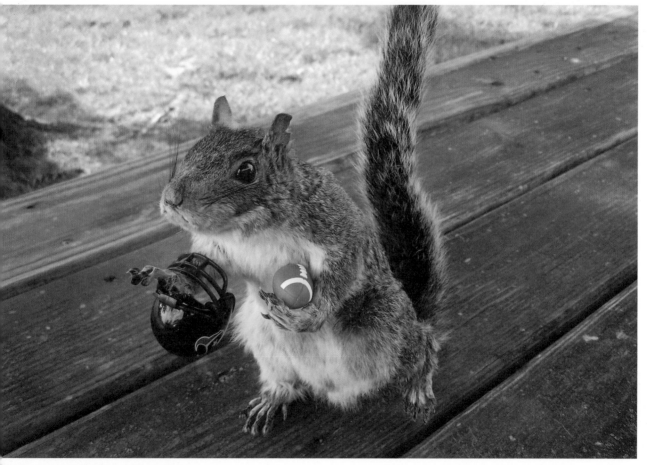

The Texans unveil their new wide receiver.

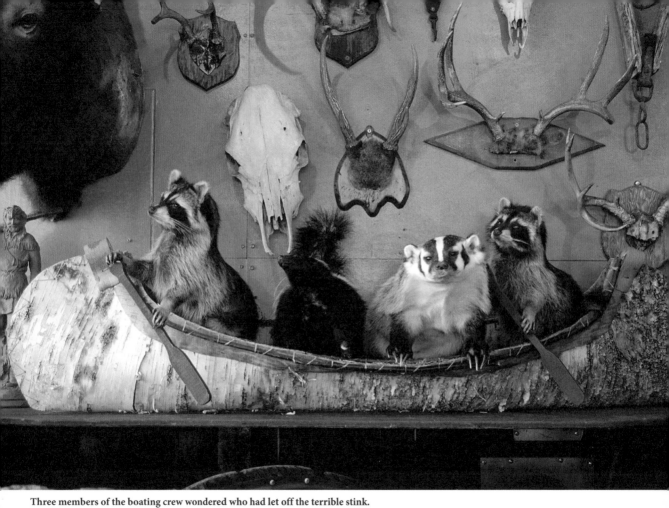

Three members of the boating crew wondered who had let off the terrible stink.

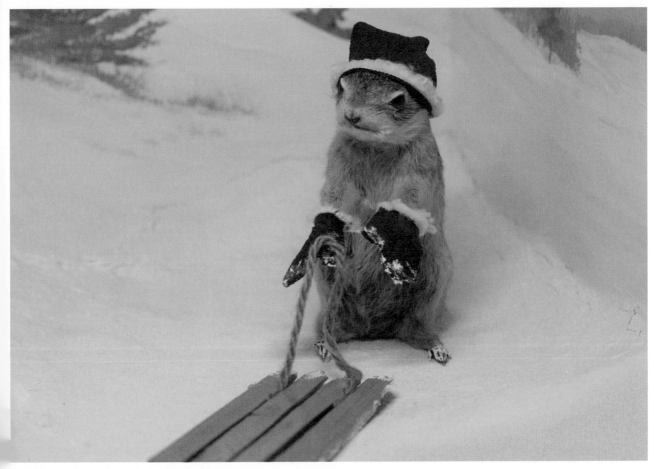

A sledding gopher with matching hat and mittens

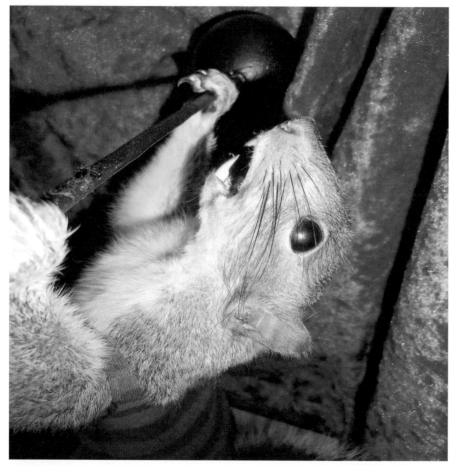

Take the strain!

best-dressed
beasts

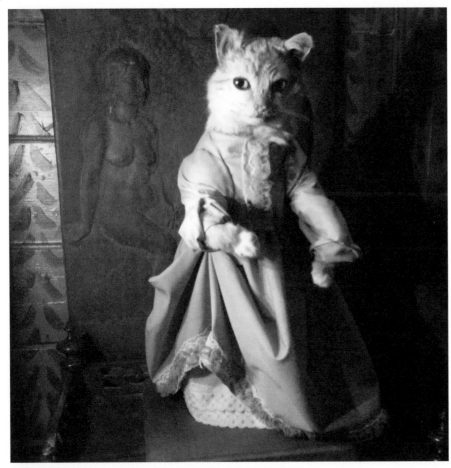

Fashionable feline
An elegant kitty, spotted at the Zetter Townhouse Hotel in London

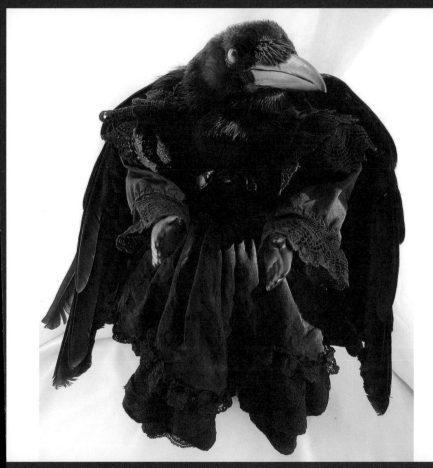

Crow in mourning

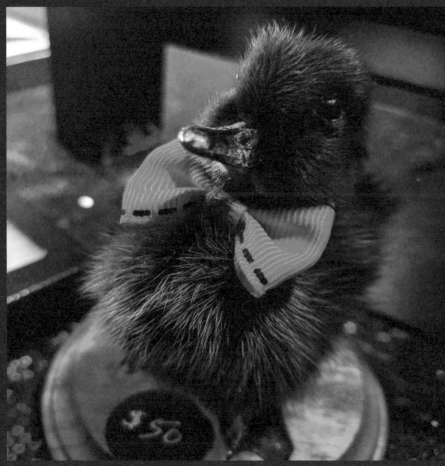

Duck in a dickie bow

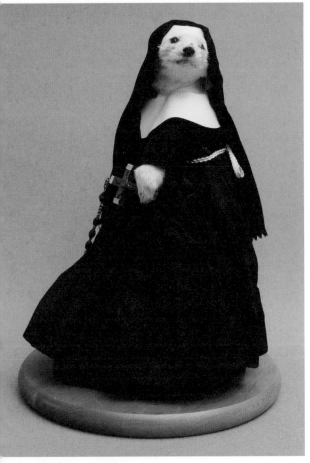

Ermine nun

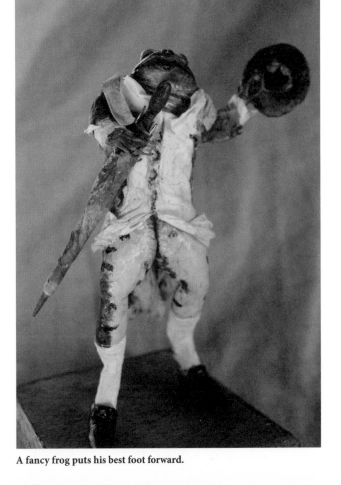

A fancy frog puts his best foot forward.

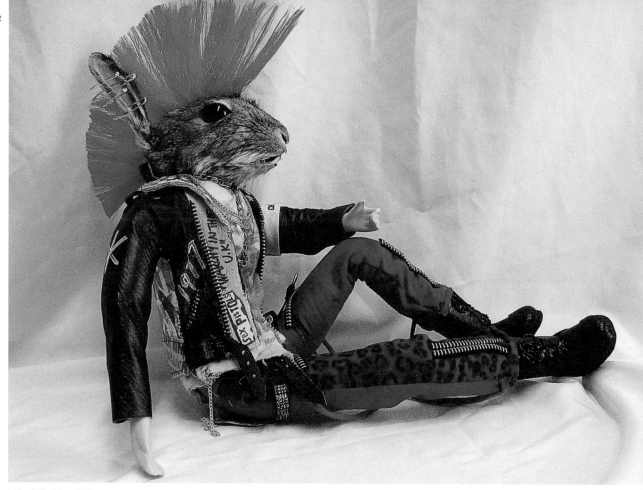

Who killed Bambi?

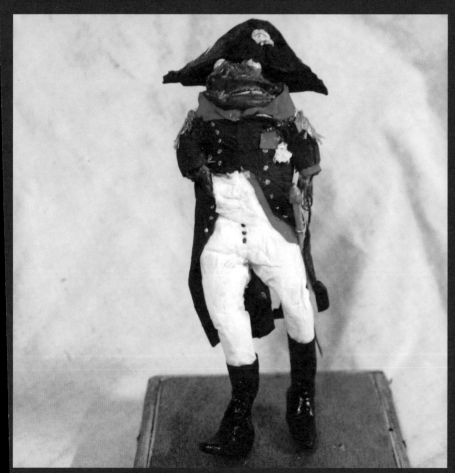

Complex Napoleon?

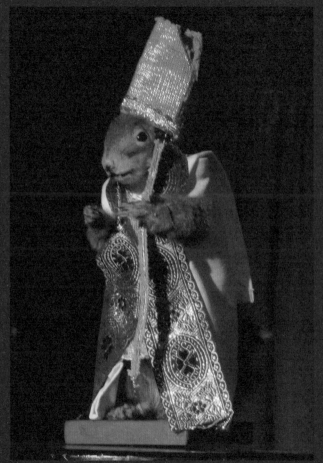

The squirrel pope blesses his flock.

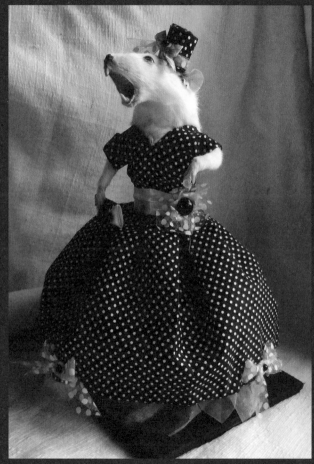

Audrey Hepburn with attitude

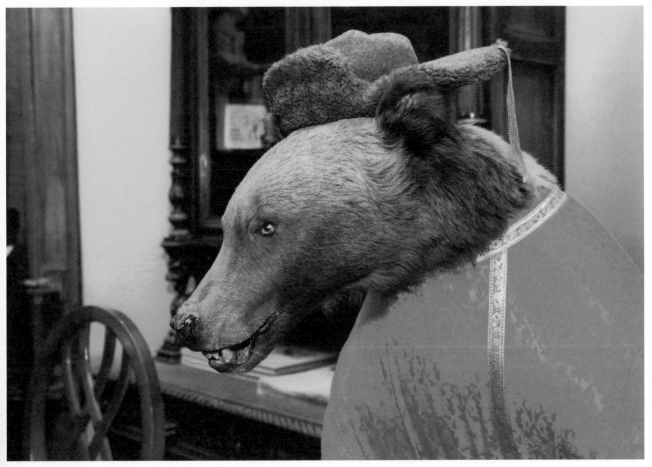

Grin and bear it

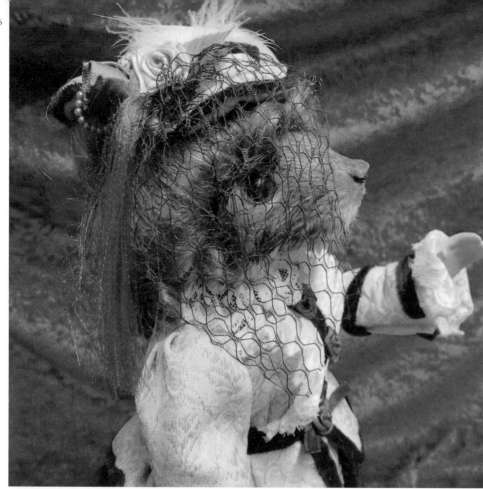

Unveiled: a veiled Edwardian lady squirrel

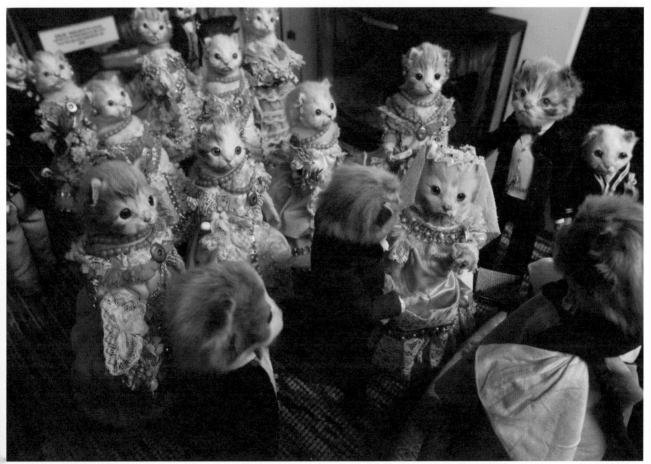

The Kittens' Wedding
Another strange scene from Walter Potter

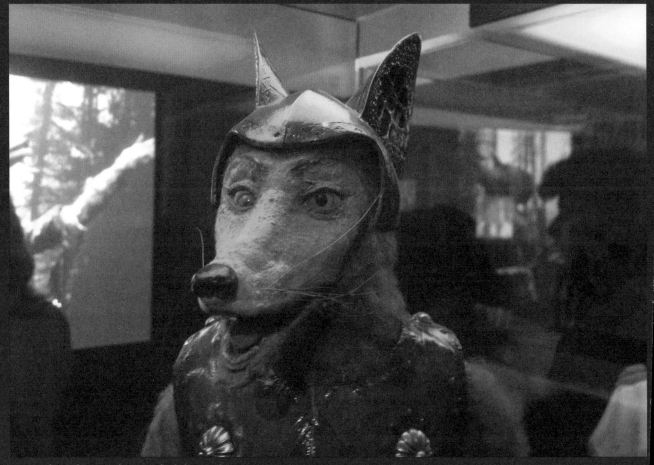

Warrior fox, in his special warrior fox helmet with extra ear protection

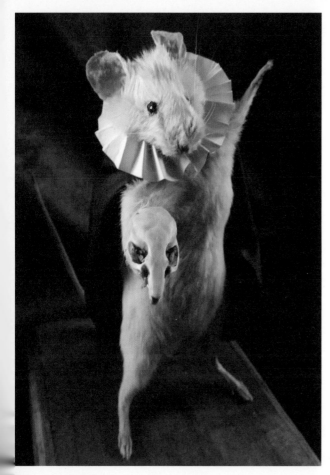

"Alas, poor Mickey..."

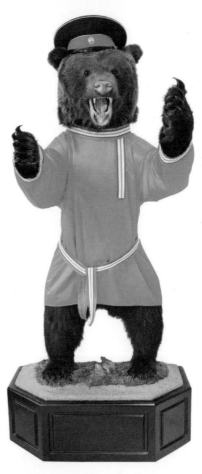

This bear is standin', not Russian!

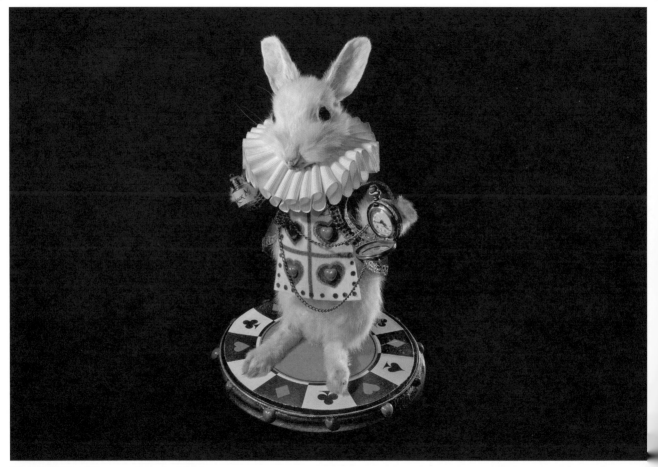

He's late! He's late! For a very important date!

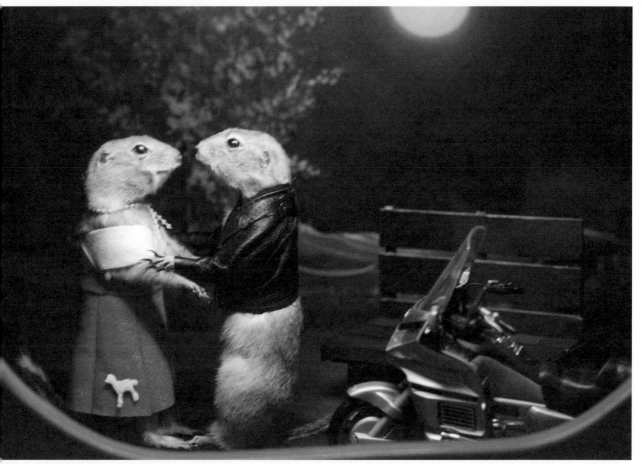

Love-struck gophers sharing a moment

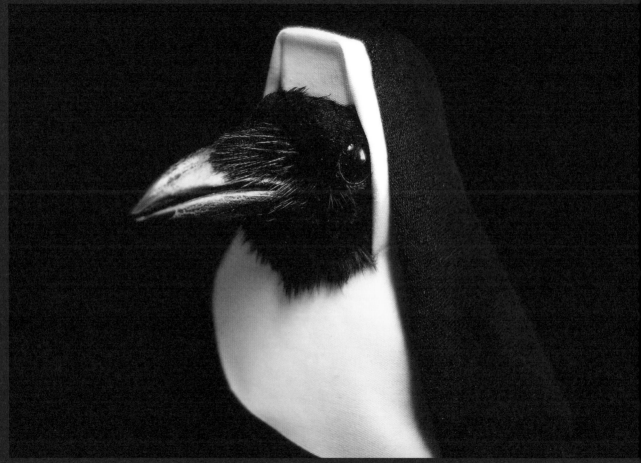

Holy crow, a corvid in a habit

domestic
bliss

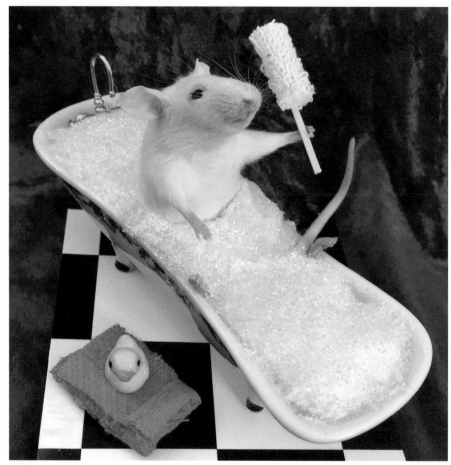

Animal ablutions
A rodent from Haus of Mouse enjoying a soak

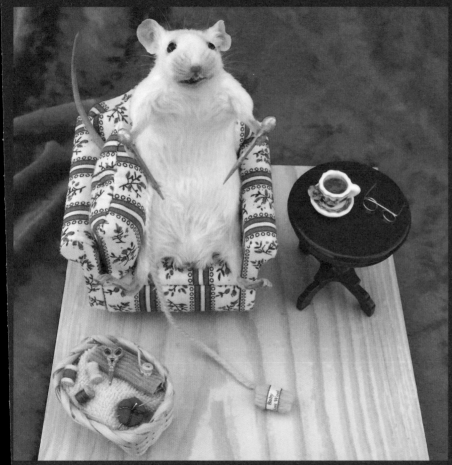

A nice cup of tea, reading glasses at the ready and a scarf to knit. Perfect.

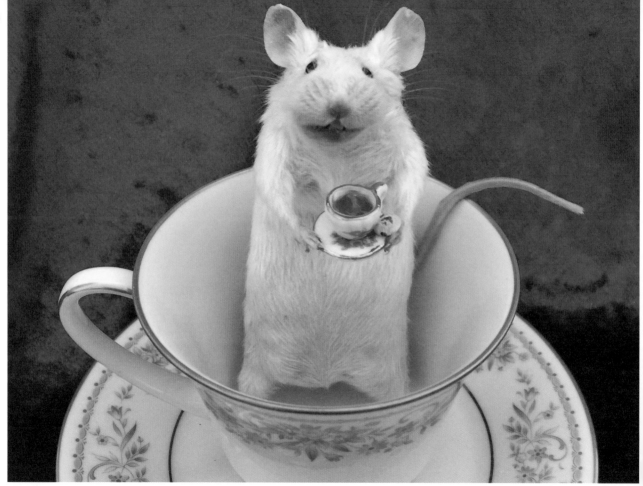

Tea should be drunk from a teacup, naturally.

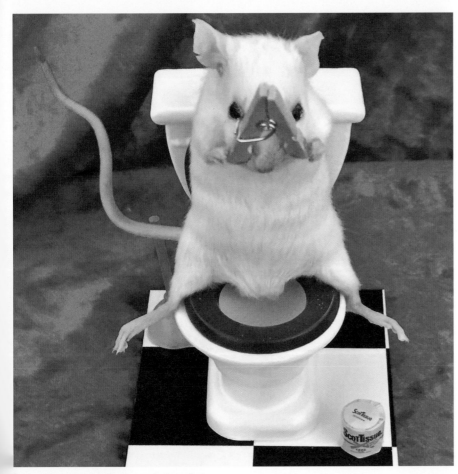

Interesting squat-on-the-seat technique there

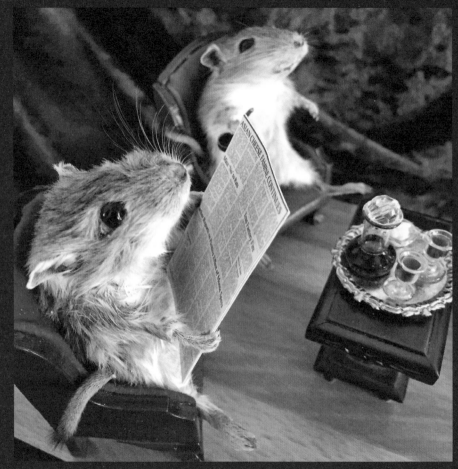

Life after escaping the rat race

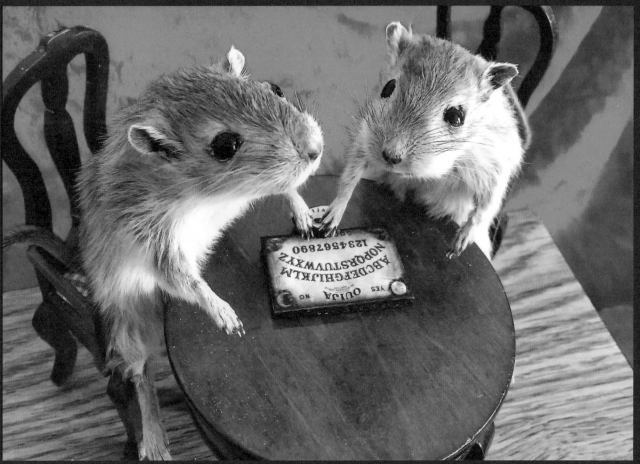

The dead commune with the even deader.

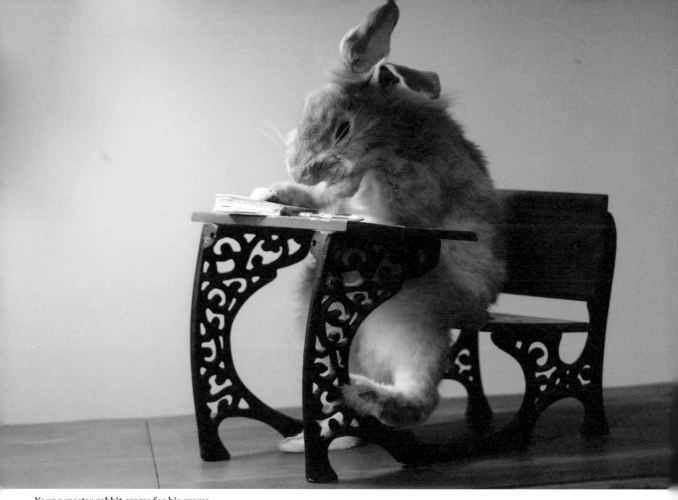

Young master rabbit crams for his exams.

out and
about

Hang on there, kitty!

Try getting to sleep after this guy has read you a bedtime story...

Smarter than the average bear in your pic-a-nic basket

Fly away, pretty bird!

Fast-forward to the early 2000s, and taxidermy took a bold step into the absurd with the Rogue Taxidermy movement. Stuffed animals started to appear in fashionable New York art galleries. This new generation of artists thought nothing of messing with nature, combining body parts to create flying goat-fish creatures or three-headed mice. And why not? While traditional taxidermists labor to produce life-like scenes, the rogue taxidermists were solely concerned with their own imaginations. And what rich – some might say warped – imaginations they were! These were scenes from the carnival, post-mortem freak shows of the fabulous and fantastic.

Today, many more taxidermists have taken to the internet to peddle their wares. Often they are entirely self-taught. If you want to have a scene created out of your twisted imagination, somebody out there will be more than happy to oblige. Is your heart set on a heavy metal band of grasshoppers? No problem. What about a sinister gang of hooligan-hamsters? Give them a couple of months, and it's yours. Maybe you will be inspired by the creations in this book. We've gathered together a selection of the wildest taxidermy out there, snapped *in situ* by incredulous travellers or placed up for sale by their proud creators. If you can think it, the chances are someone's stuffed it.

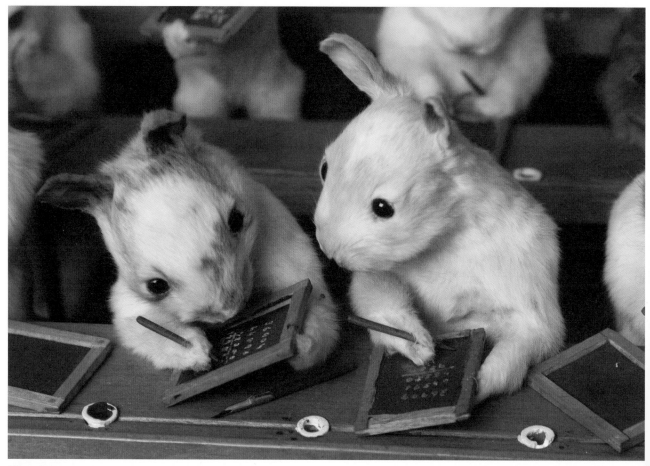

Kit academy
A Walter Potter original from the 19th century

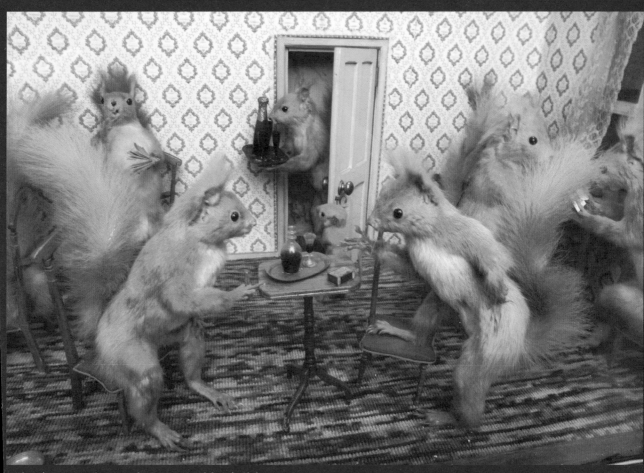

Rodents' retreat – relaxing at the Private Gentleboar's Club

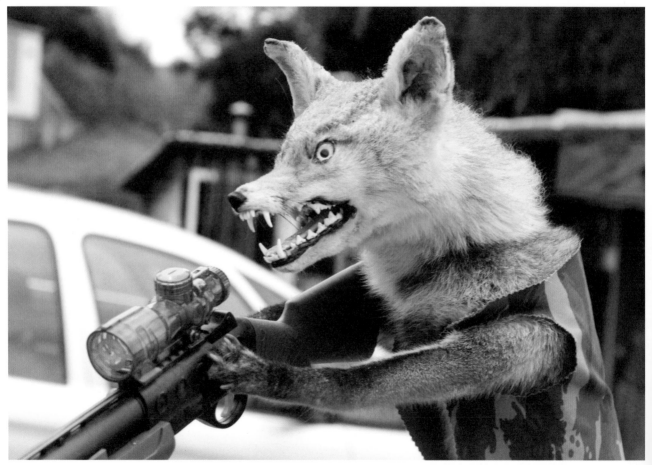

Fox, hunting

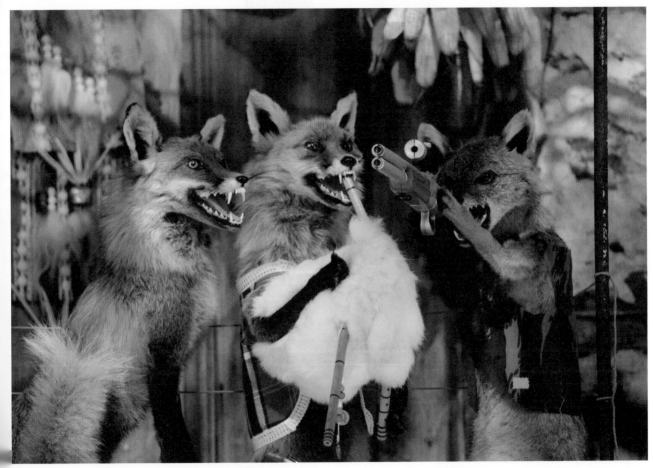

No self-respecting fox hunts without a musical accompaniment.

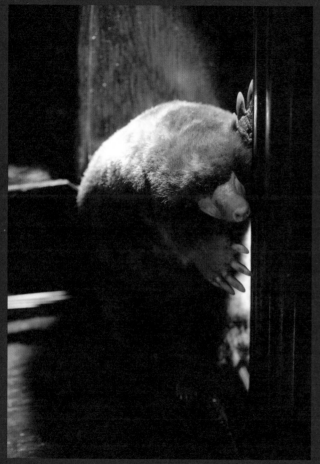

Think there might be a mole

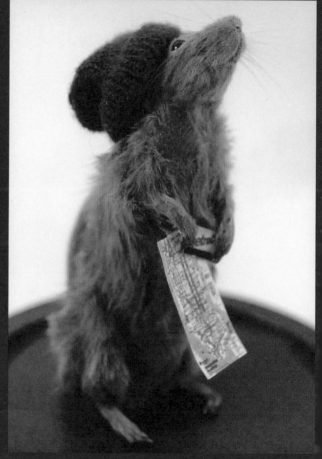

Mouse on the Metro

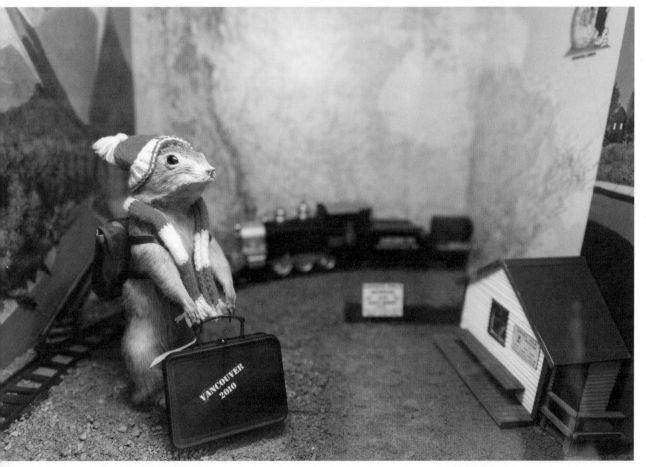

Not sure this gopher will fit inside that train.

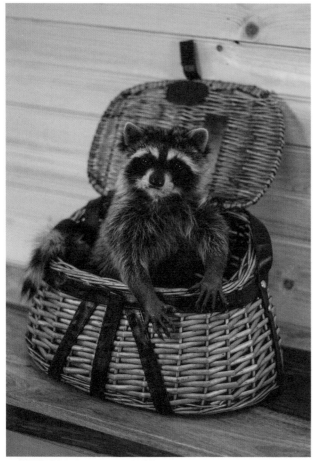

Picnic thief

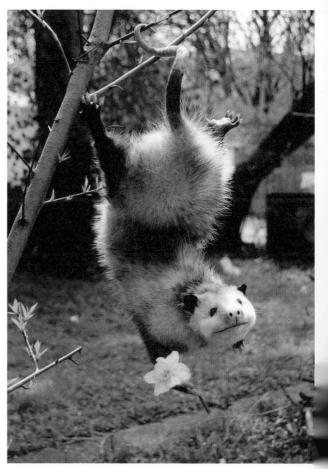

Opossum in springtime

house of
horrors

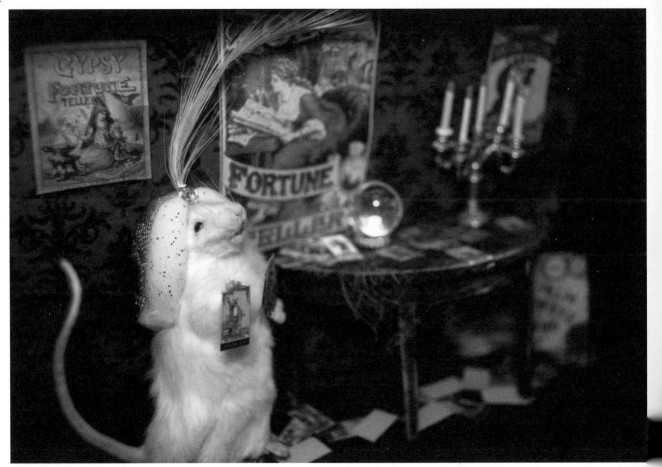

Mystic Mouse

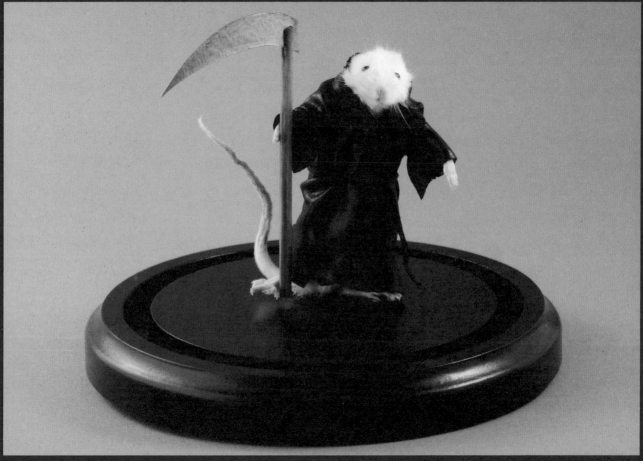

The Grim Twitcher

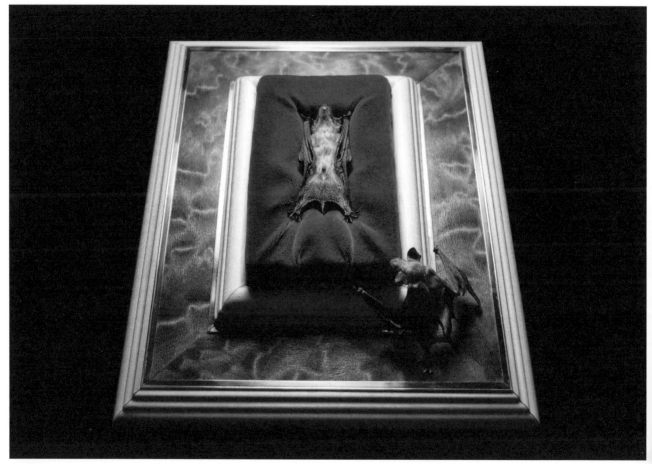

Bat wake
A macabre Gothic scene from Jeremy Johnson

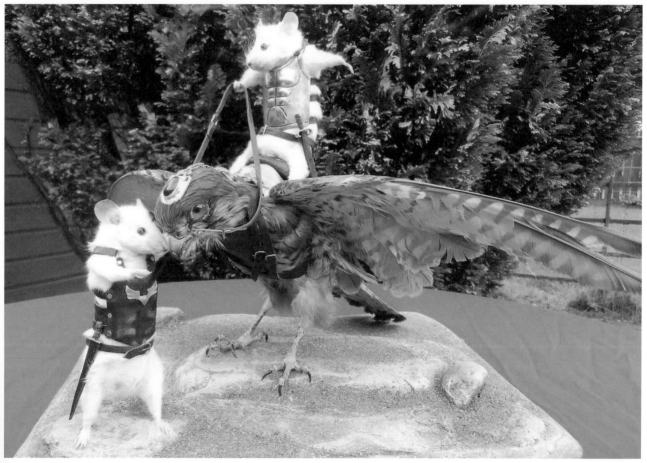

Greek heroes take flight.

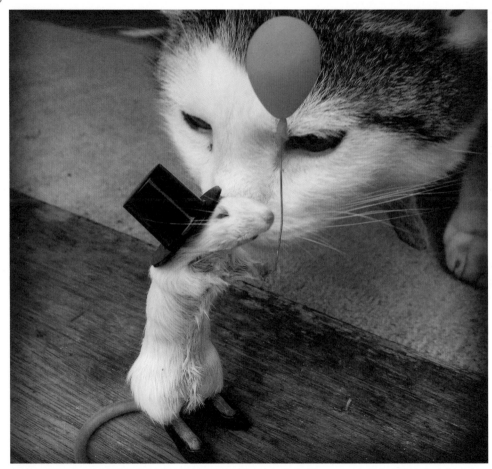

"Why isn't it moving?" The cat is alive. And very confused.

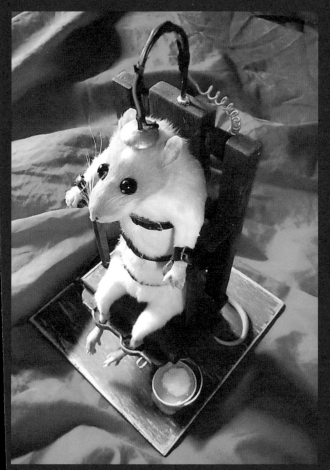

Time to die. Again…

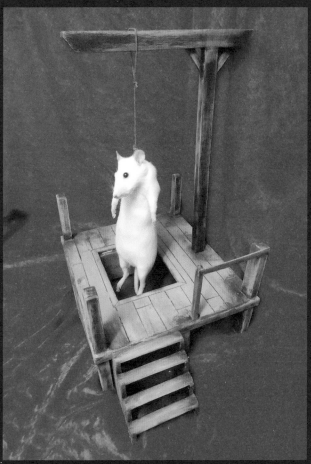

… and again

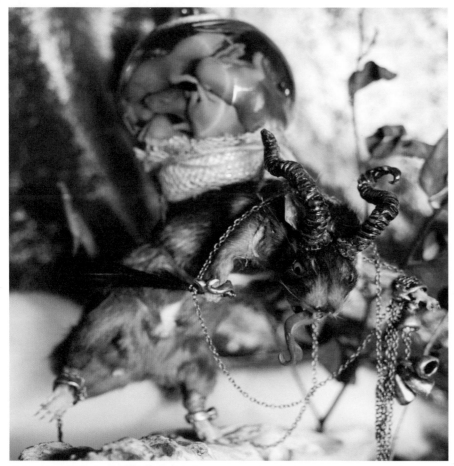

Half-goat (well, squirrel), half-demon, the Krampus punishes children who misbehave at Christmas.

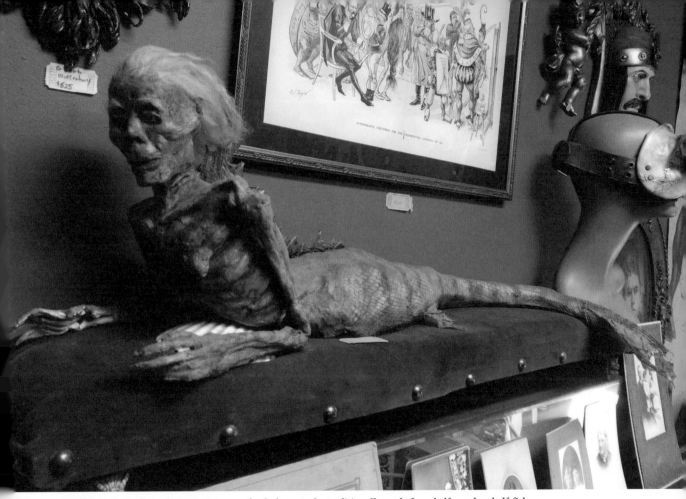

Fiji mermaid. This curiosity from the past was once a freak show staple, traditionally made from half-monkey, half-fish.

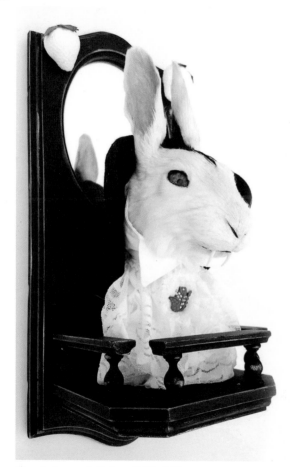

Vampire bunny. Is that a reflection? Hmmm.

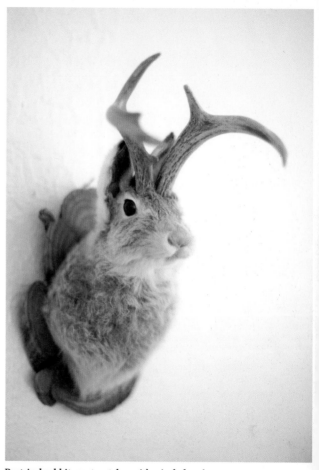

Part-jackrabbit, part-antelope, it's a jackalope!

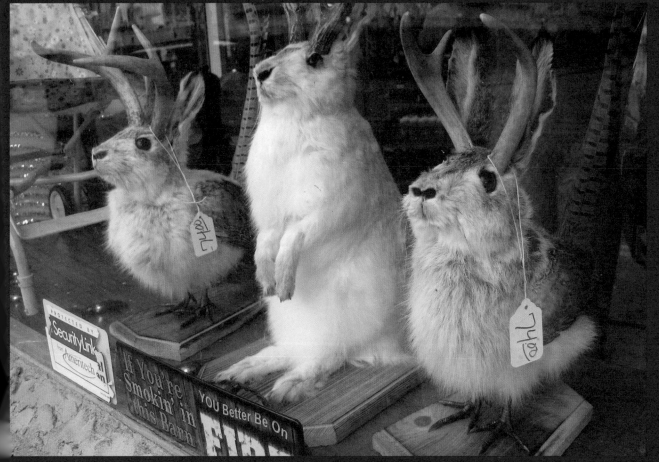

A jackalope and two chicajackalopes?

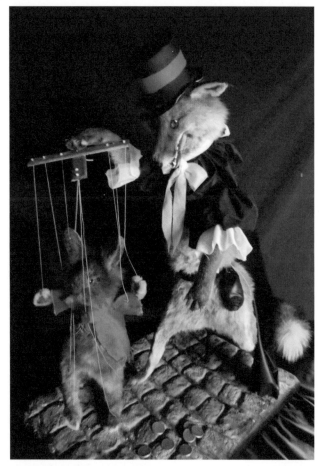

A crafty fox pulling some strings

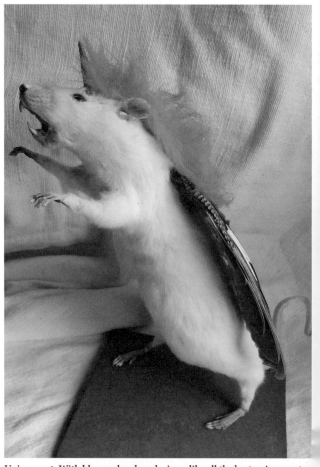

Unicorn rat. With blue mohawk and wings, like all the best unicorn rats.

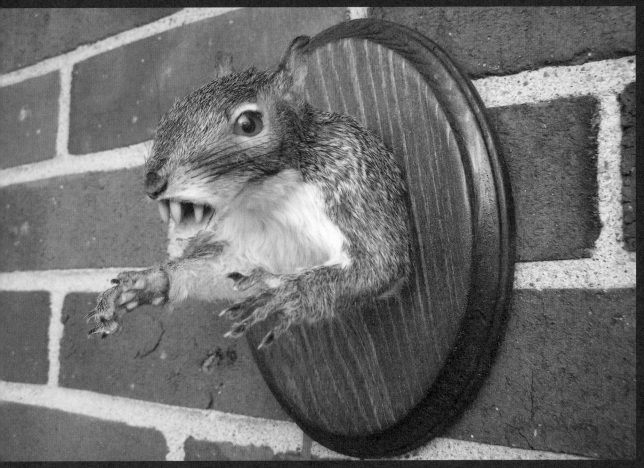

Zombie Squirrel. Death does not become her.

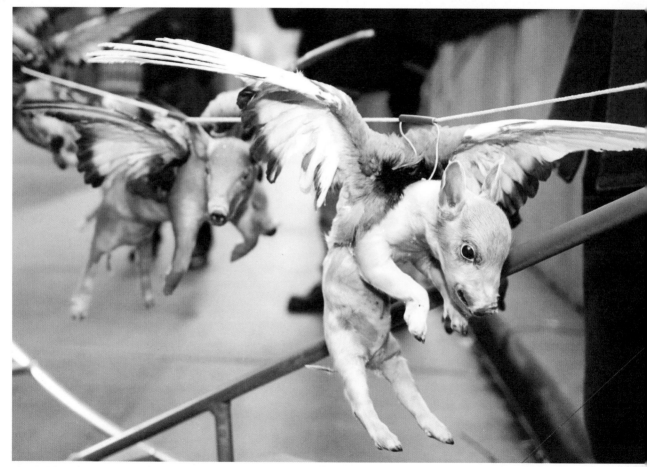

Flying pigs
Out and about on parade in Toronto

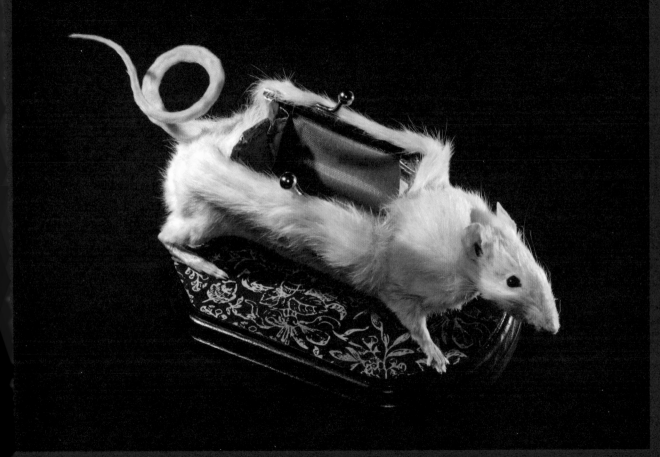

'Shall I pay? No? Oh, ok then."

Acknowledgments

Image credits

Special thanks to:
10l, 11, 20, 25r, 31l, 31r, 32, 33l, 33r, 34, 42, 51r, 53, 59l, 92l Mario Broutin @ mbcreature
10r, 16r, 36, 39, 41, 80l Safari Works Décor
12, 16l, 17, 19, 30, 40, 43, 93 Rick Nadeau @ thesquirrelhole.com
13r, 14, 22l, 22r, 23l, 23r, 70, 72l, 72r, 74, 78l, 80r, 84, 88, 94 Jeremy Johnson @ Meddling with Nature
15, 18, 28, 64, 65, 66, 67, 68, 69 Haus of Mouse Taxidermy
25l, 26, 46, 49, 52, 56, 62, 85, 87l, 87r Livic's Taxidermy
54r, 92r Spookys Artwork
90l Jana Rose Arts

Additional credits:
8, 57, 75 Marc Hill/Alamy Stock Photo, 13l lightningfades @ Flickr, 24, 37, 45, 61 Alan Levine @ Flickr, 27 Eileenmak @ Flickr, 29 Lorna Mitchell @ Flickr, 38 acceptphoto/Shutterstock.com, 44 Emily Mathews @ Flickr, 48 Peter Burka @ Flickr, 50 tome213/Shutterstock.com, 51l, 78r, 82, 83 Brooklyn Taxidermy @ Flickr, 54l, 58 istolethetv @ Flickr, 55 Olga Zinovskaya/Shutterstock.com, 59r ID1974/Shutterstock.com, 60, 95 Michaelparkart/Shutterstock.com, 73 Oleg Elkov/Shutterstock.com, 76 Pavel Dzhunev/Shutterstock.com, 77 Ellena Bozhkova/Shutterstock.com, 79 Mack Male @ Flickr, 86 Engyles @ Flickr, 89 Cory Doctorow @ Flickr, 90r Paul Rich Studio/Shutterstock.com, 91 Robert Couse-Baker @ Flickr